CONNECT & COLOR

CELTIC DESIGNS

Racehorse Publishing books may be purchased in bulk at special discounts for sales promotion, corporate gifts, fund-raising, or educational purposes. Special editions can also be created to specifications. For details, contact the Special Sales Department, Skyhorse Publishing, 307 West 36th Street, 11th Floor, New York, NY 10018 or info@skyhorsepublishing.com.

Racehorse Publishing™ is a pending trademark of Skyhorse Publishing, Inc.®, a Delaware corporation.

Visit our website at www.skyhorsepublishing.com.

10 9 8 7 6 5 4 3 2 1

Cover and interior artwork by George Toufexis

Print ISBN: 978-1-944686-78-9

Printed in the United States of America

CONNECT & COLOR
CELTIC DESIGNS

AN INTRICATE COLORING AND DOT-TO-DOT BOOK

George Toufexis

Racehorse Publishing

DOT-TO-DOT GUIDE

- When there is more than one main object or design element on a page, each element begins with a black square and ends with a blank one.

- When going from dot to dot, keep your line curved for a more natural look.

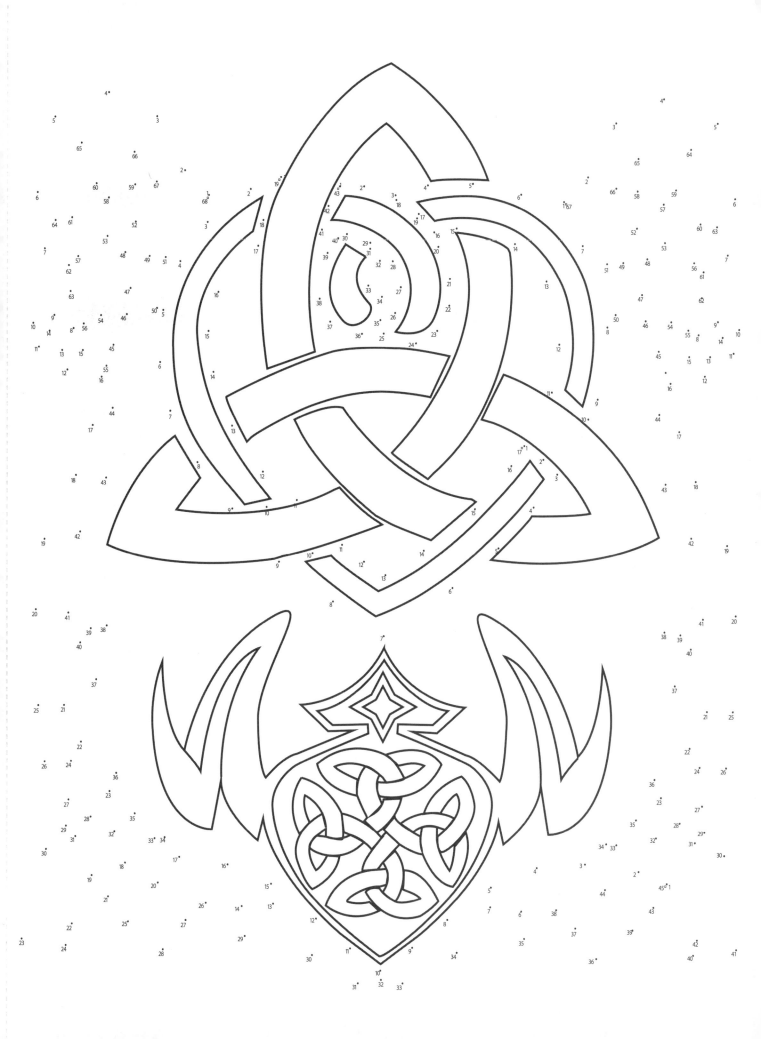

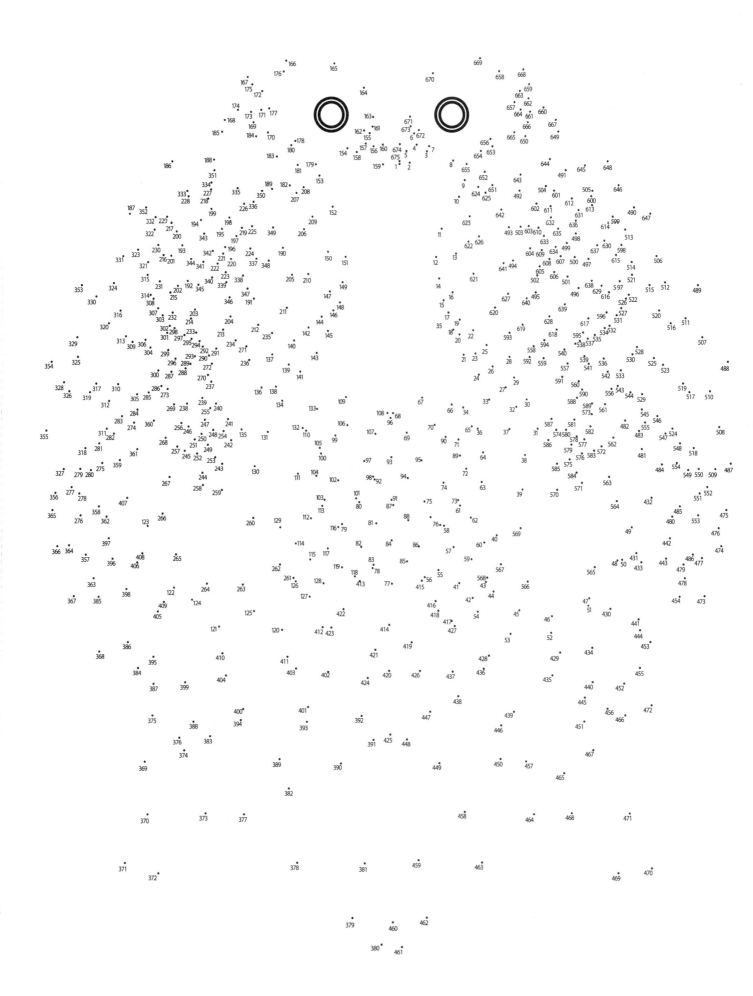

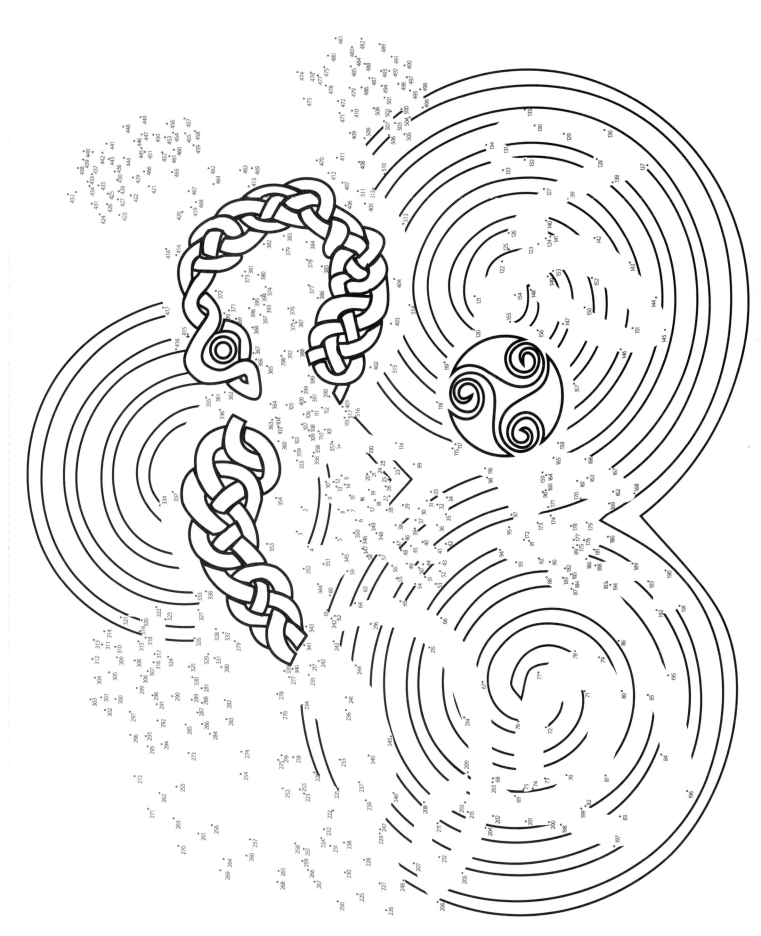

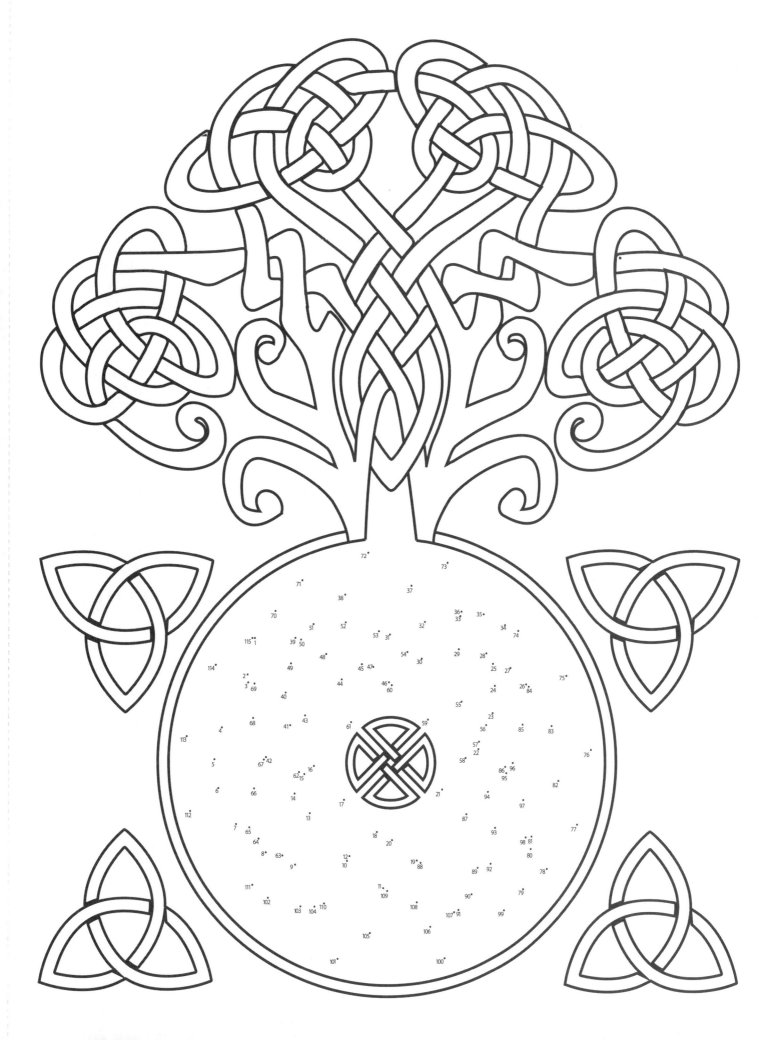

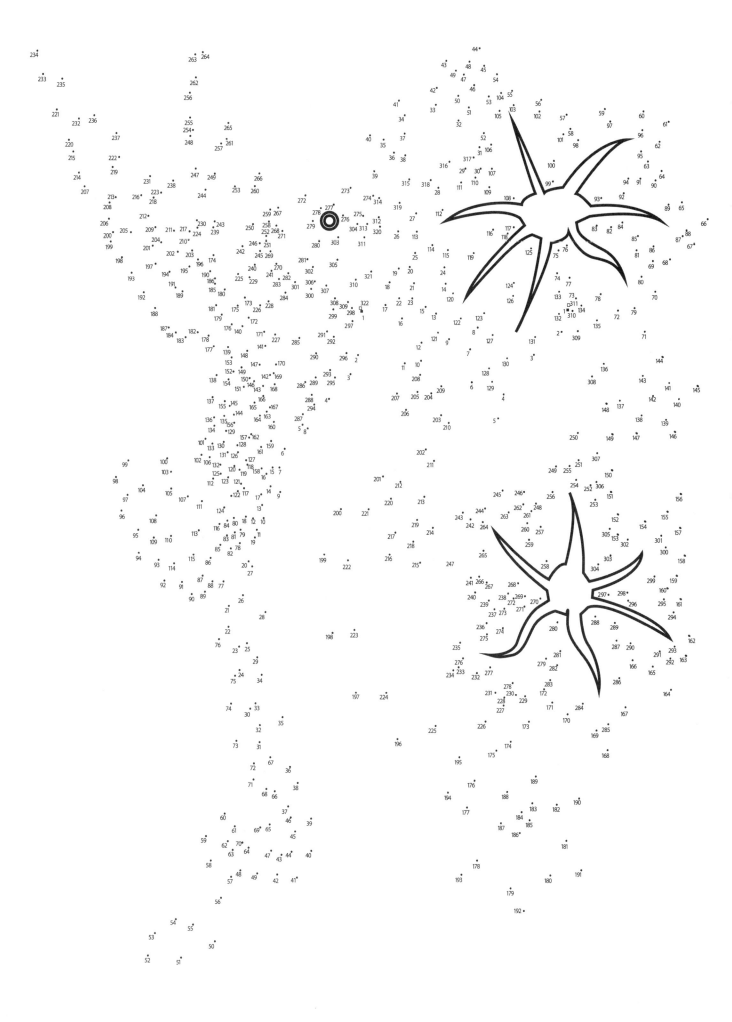

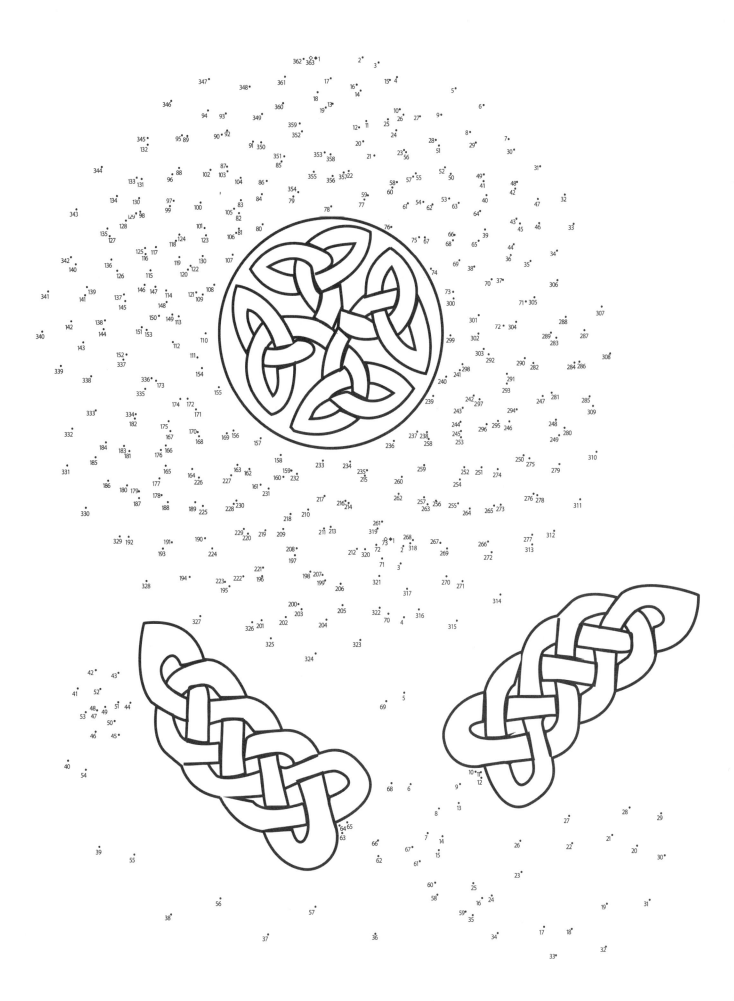

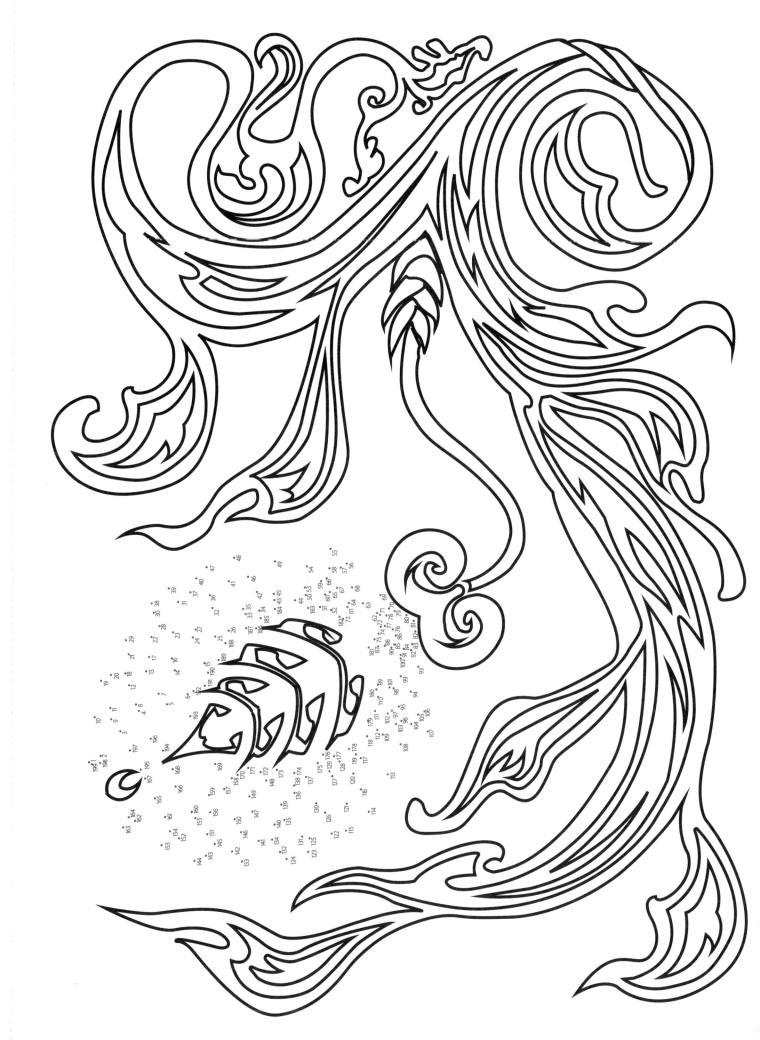

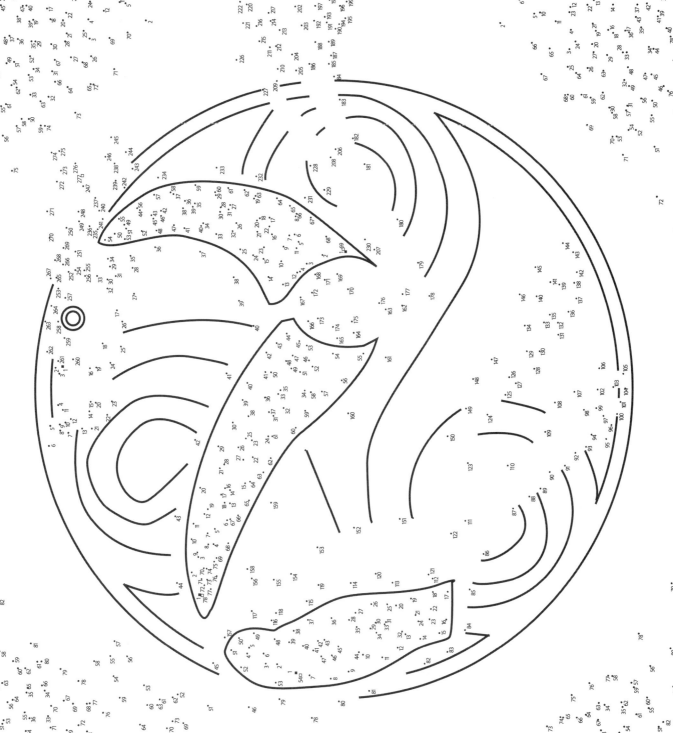

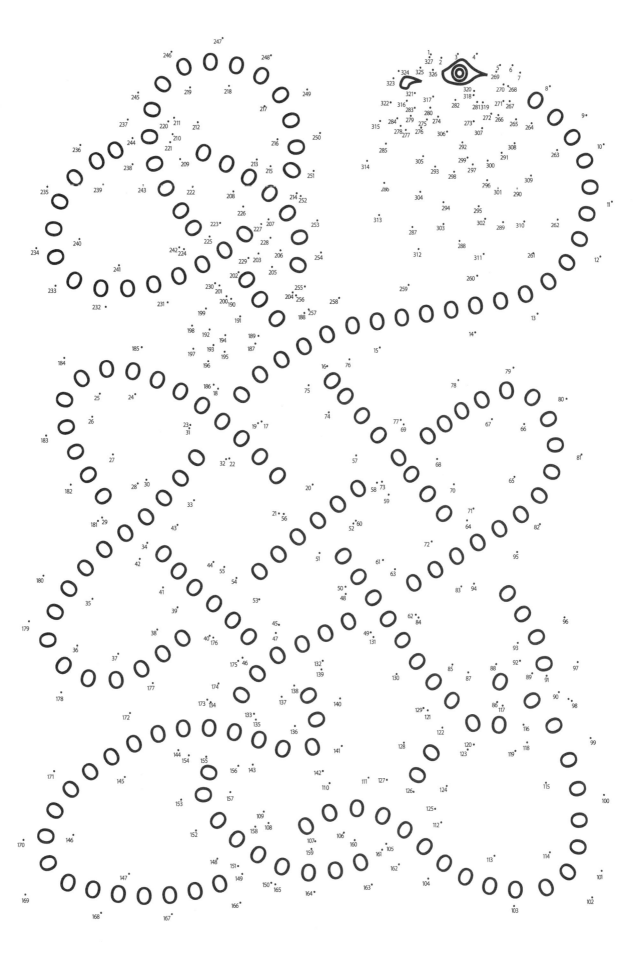

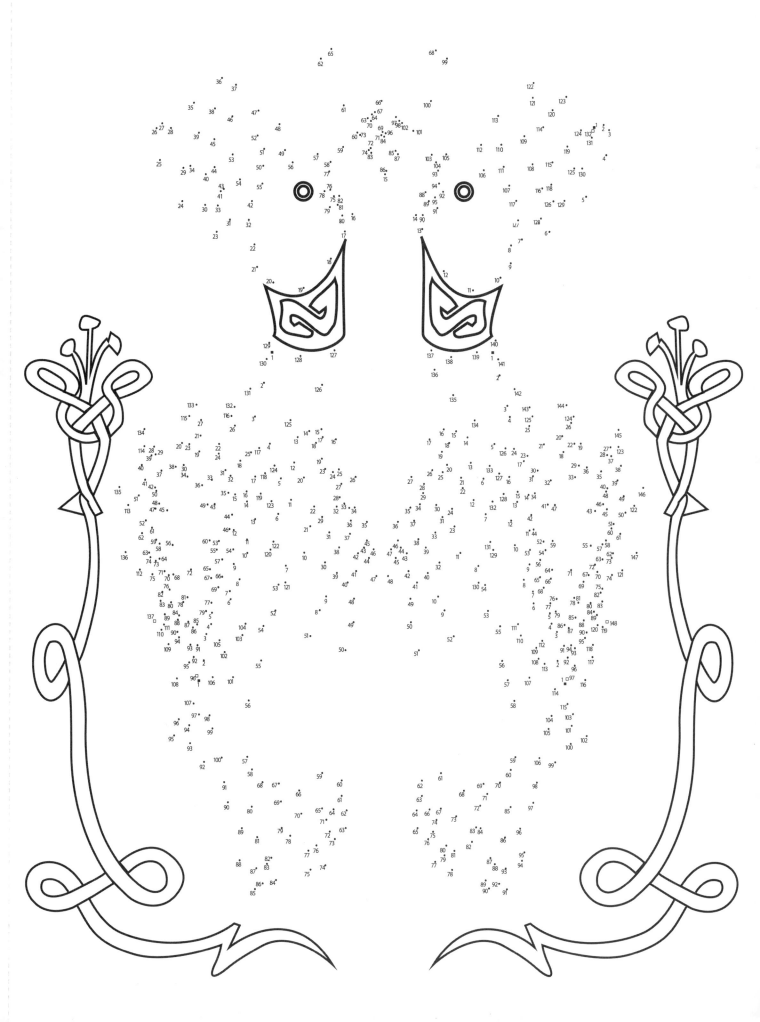

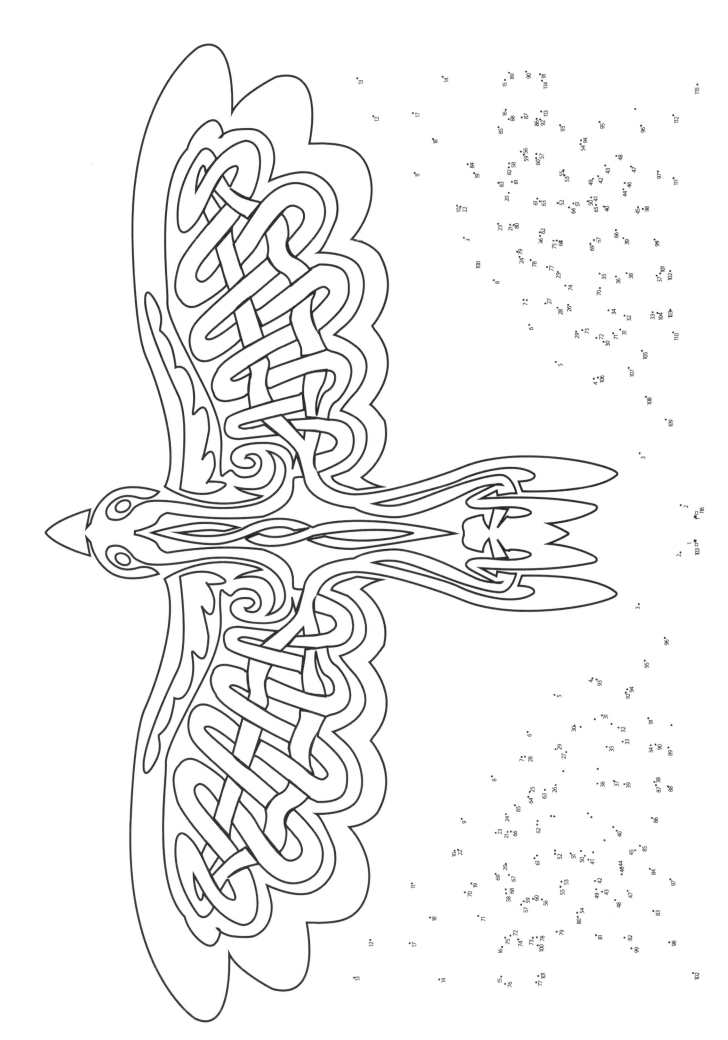

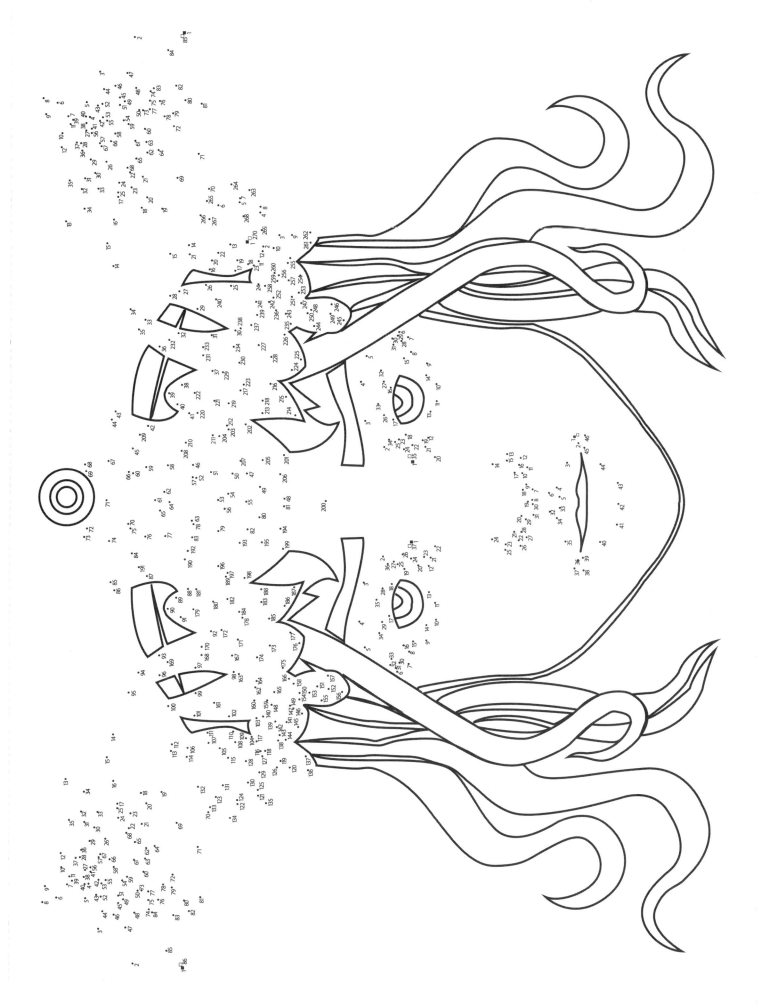

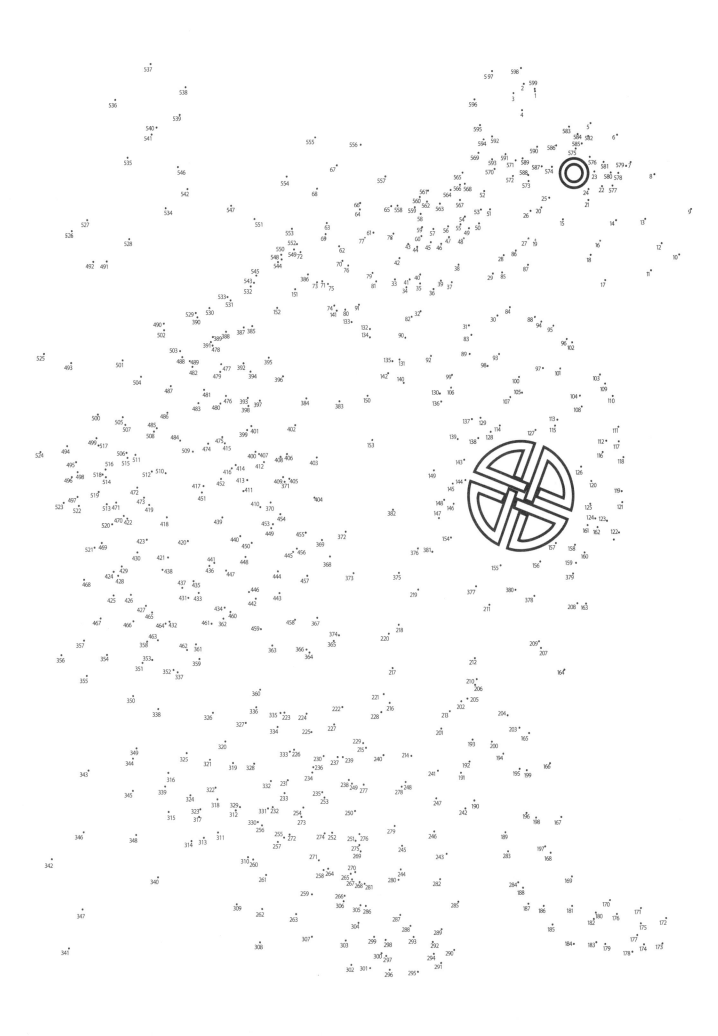

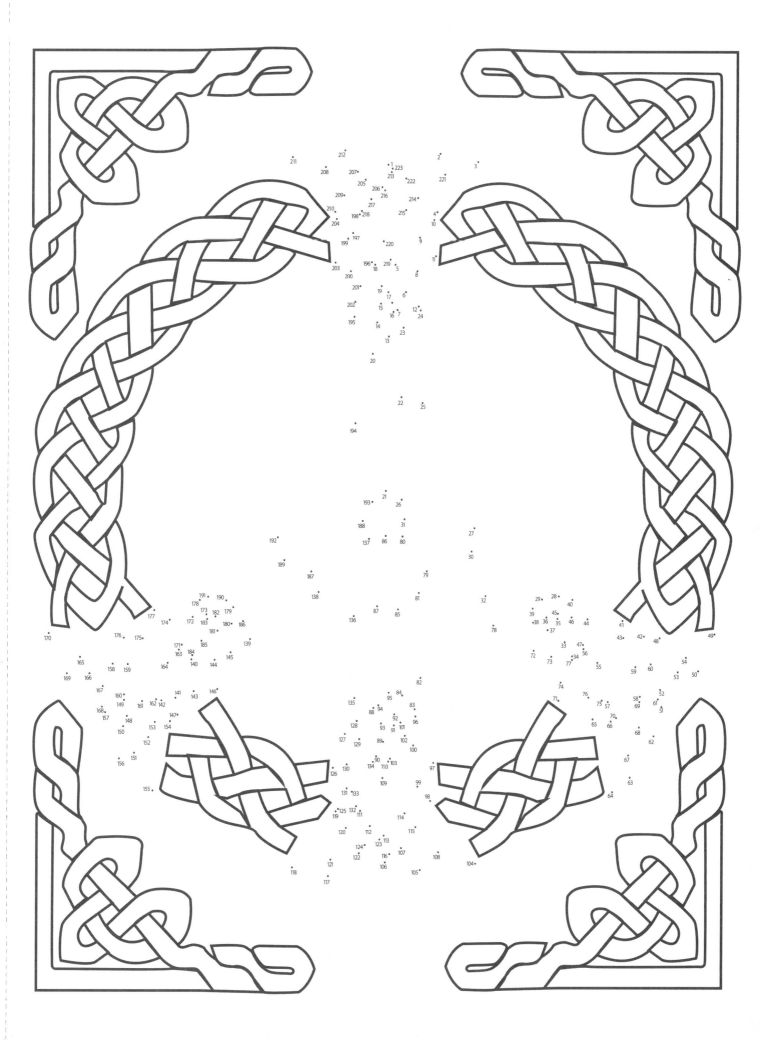

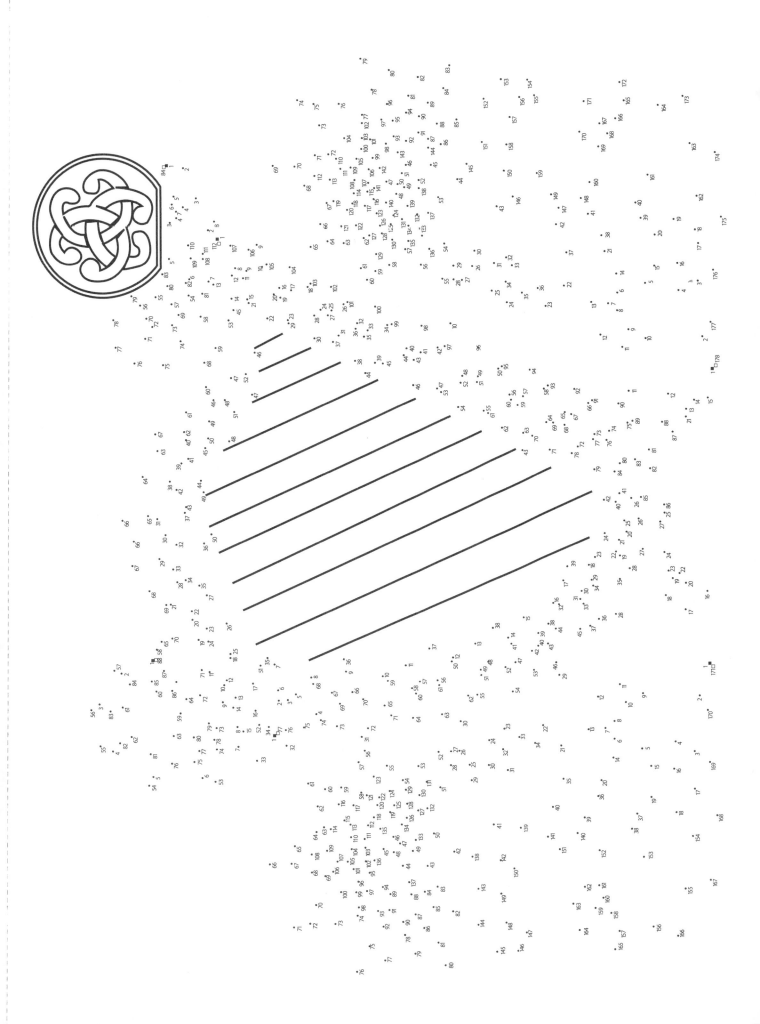

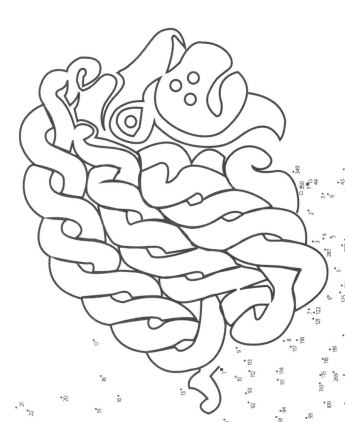

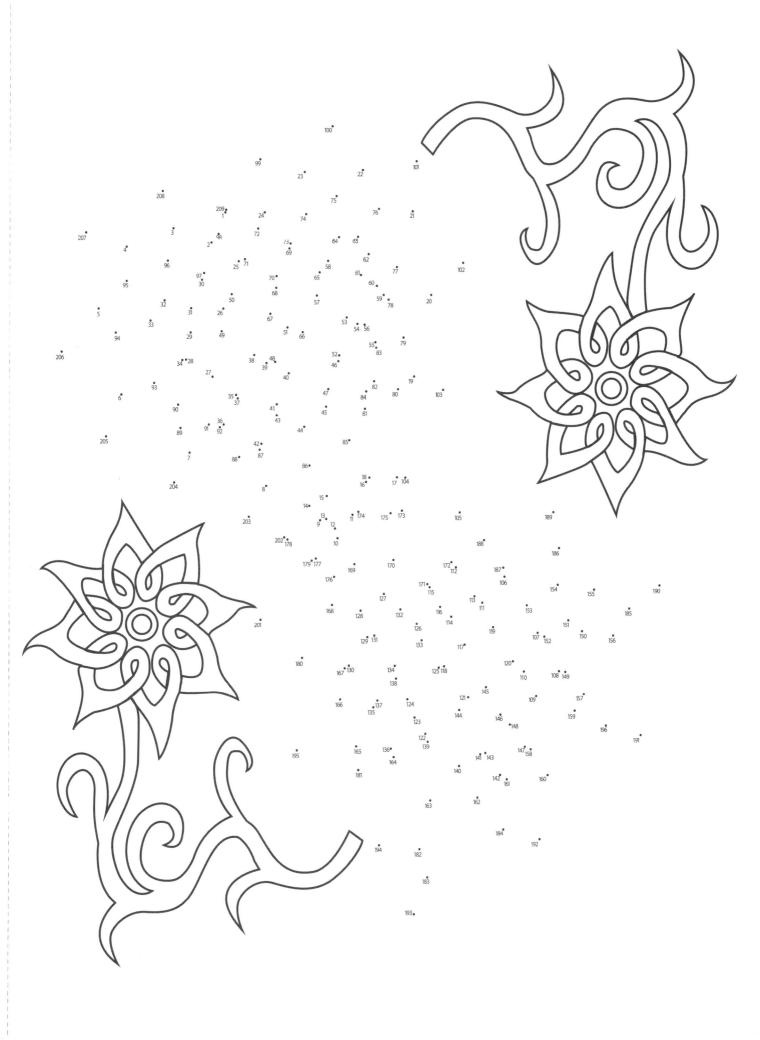

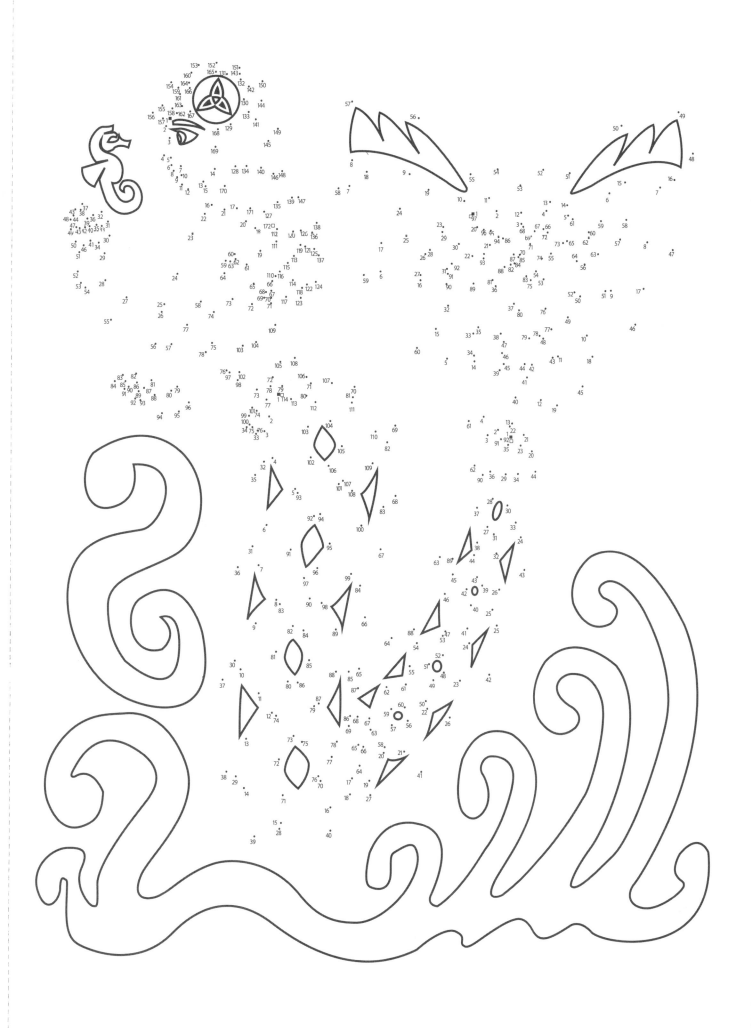

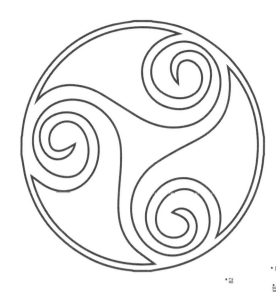
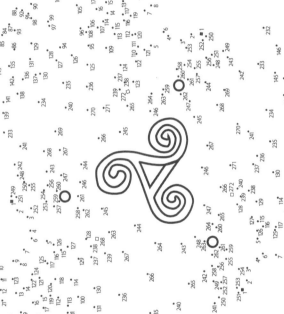
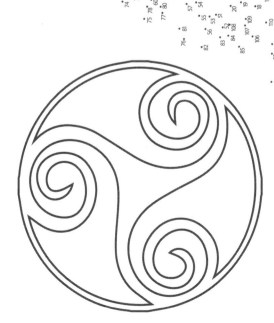

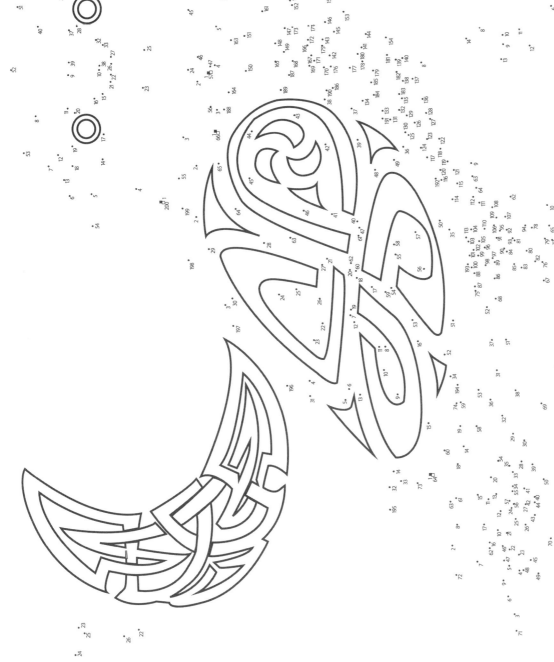

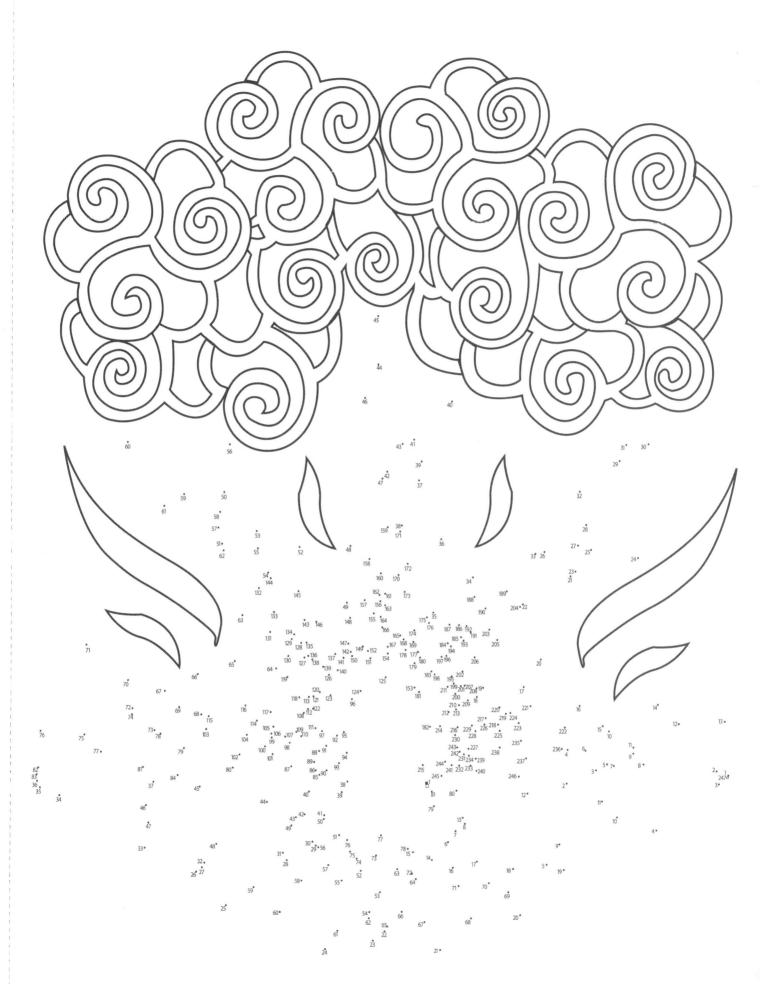

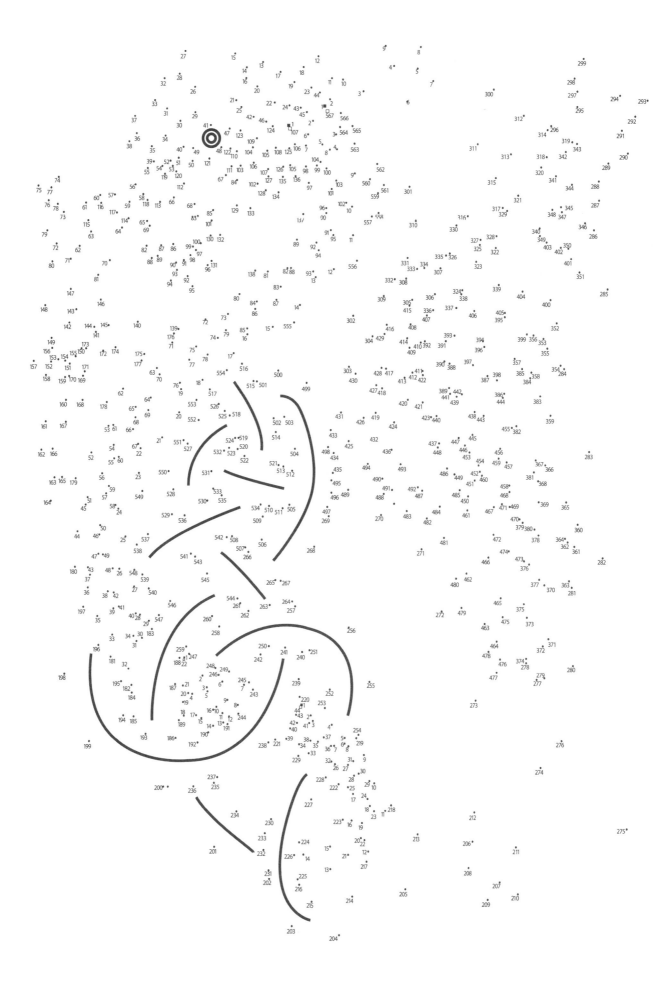

ANSWER KEY

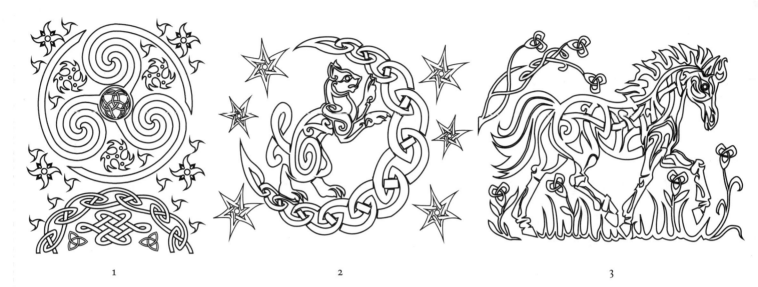

1 2 3

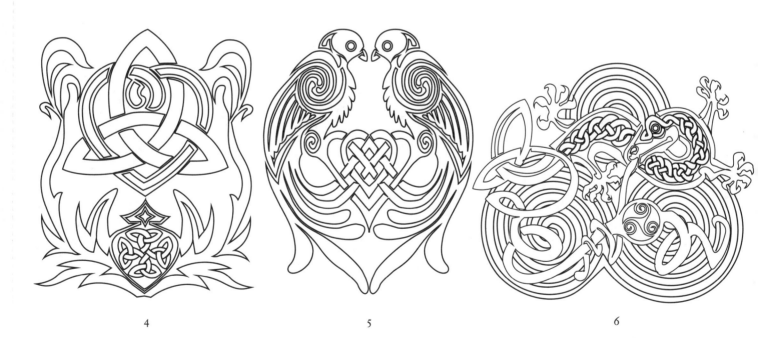

4 5 6

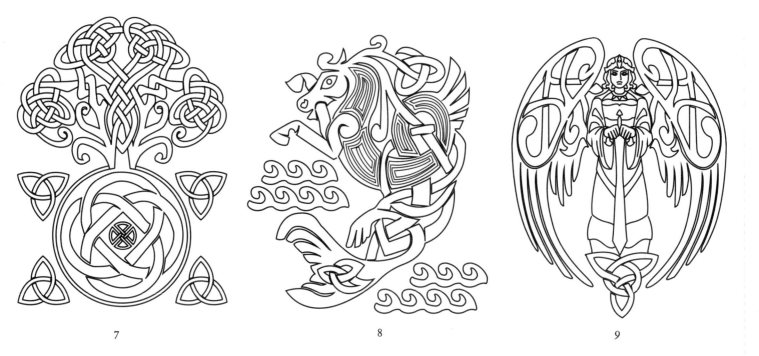

7

8

9

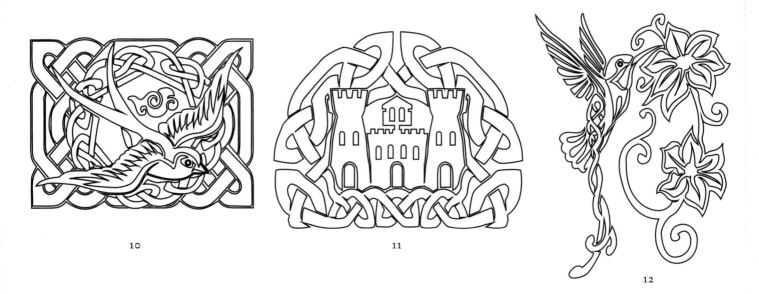

10

11

12

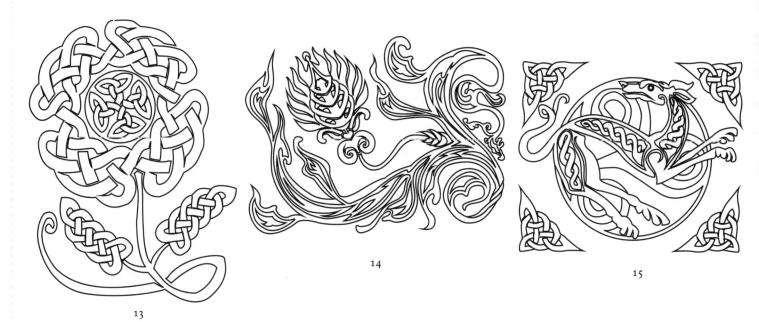

13

14

15

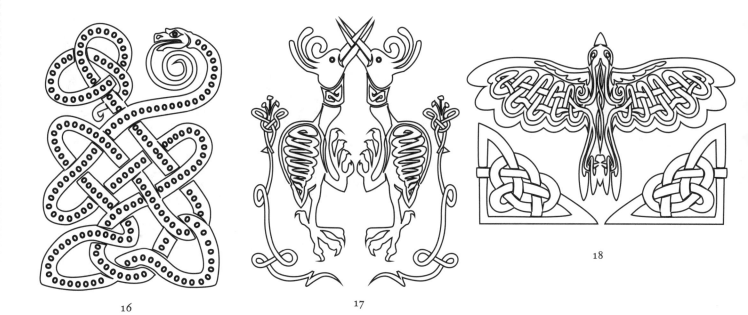

16

17

18

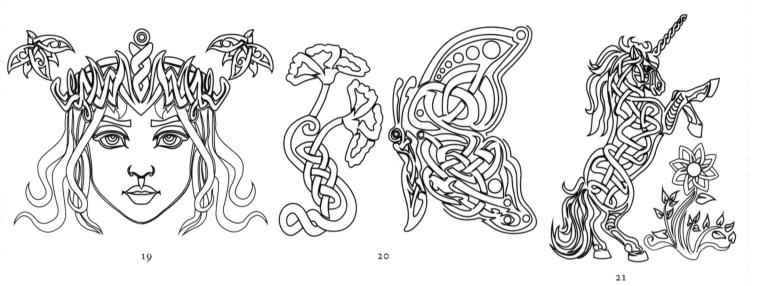

19

20

21

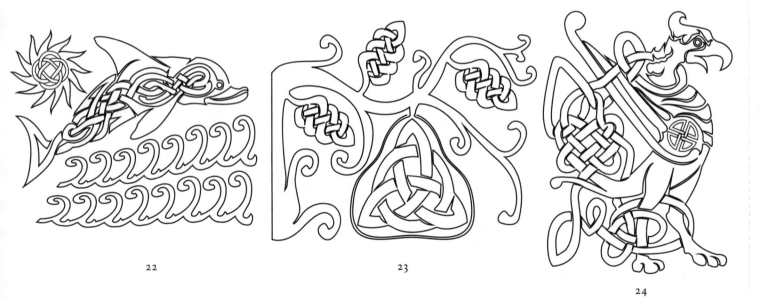

22

23

24

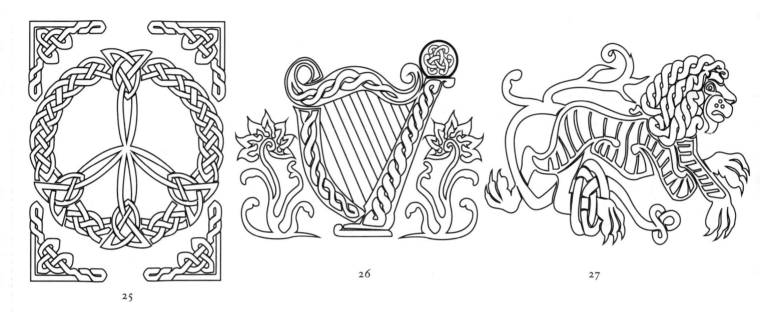

25

26

27

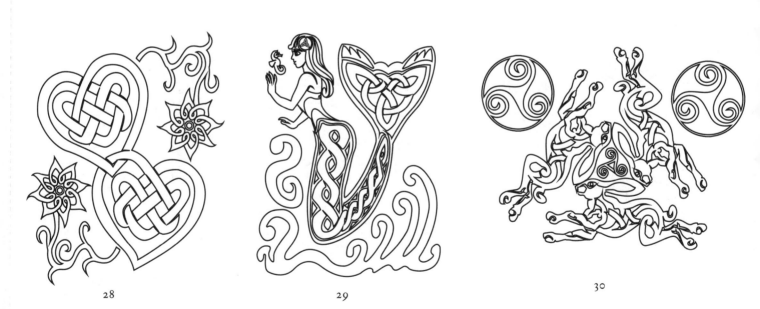

28

29

30

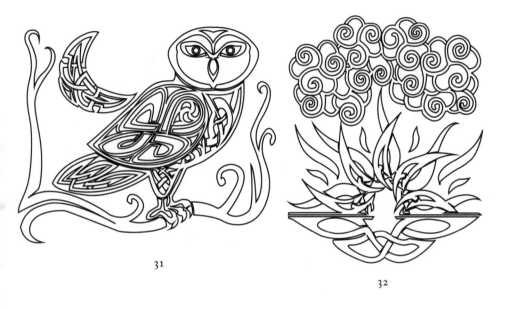

31

32

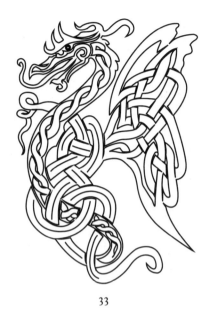

33

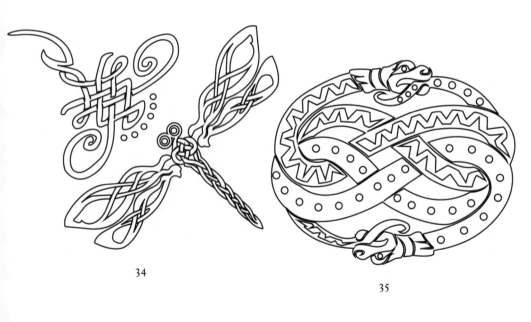

34

35

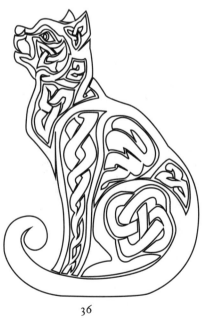

36

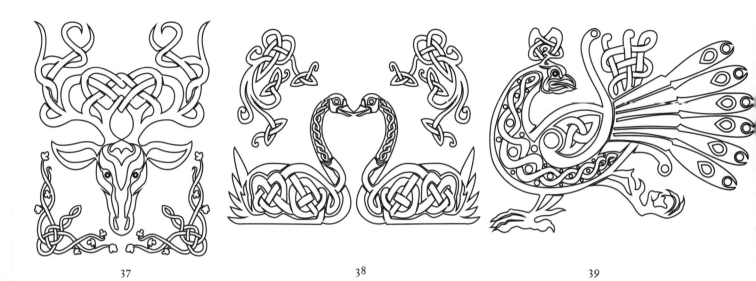

37

38

39

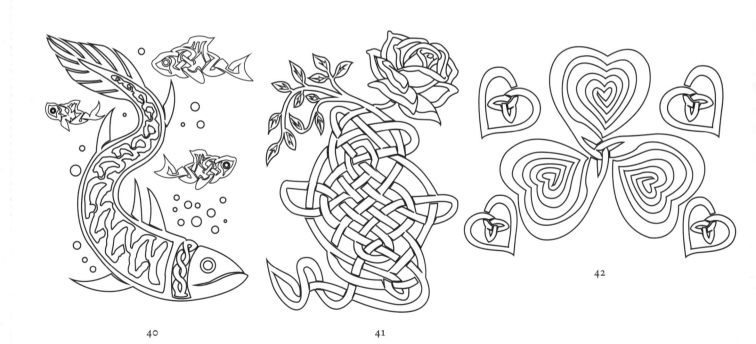

40

41

42

43

44

45